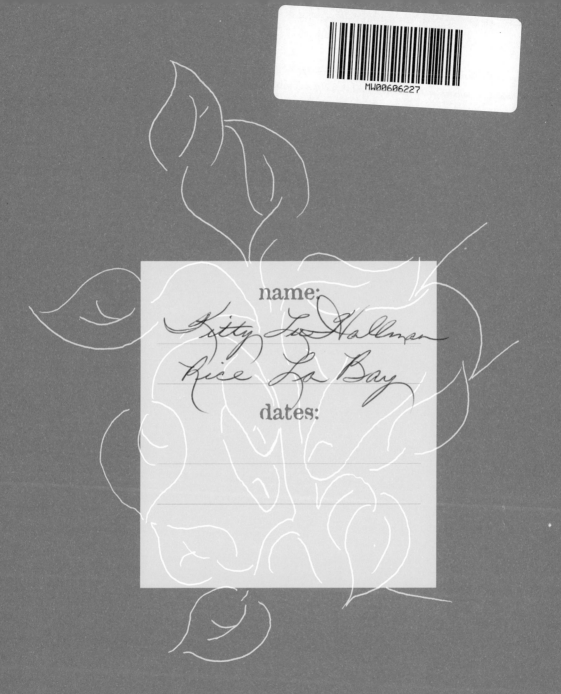

name:

Kitty Lu Hallman

Rice La Bay

dates:

I came to explore the wreck.
 The words are purposes.
 The words are maps.
 I came to see the damage that was done
 and the treasures that prevail.

Adrienne Rich, Diving into the Wreck

Only when one is connected to one's own core is one connected to others...An

for me, the core, the inner spring, can best be refound through solitude.

Anne Morrow Lindbergh, Gift From the Sea

Nov. 7, 2003 — Month of Morty!
Morty lived life with dignity, & without complaint.
He was GREATER than any general, politician, athlete, nor was famous because he was kind, humble, gentle, loving, & full of laughter.

How strange our world is — The things that we can readily touch, the things so real to our senses, are far less real than the things we cannot taste, smell, or touch. "Concretes" are less real than what we feel in our minds & remember in our hearts. They are less substantial than love, loss, loneliness, & friendship — All of which outlast the world.

Nov. 19 — Just received E-MAIL that my diamond will be sold to bring in money to start the E-doch Morty La Bay Scholarship foundation at Hyde Park — It was supposed to go to Morty's

wife.

Nov. 24

"The hands of every clock are shears, trimming us away scrap by scrap, & every timepiece with a digital readout blinks us toward implosion." DEAN KOONTZ <u>FEAR NOTHING</u>

Dec. 6

Slowly I have learned that I must not care too much about being alone. I must not care too much about what I cannot change. Like all of us in this storm between birth & death, I can bring no great changes on the world, only small changes for the better (I hope) in the lives of those I direct or teach, or the precious little ones I love. They provide the only light in which I am able to flourish.

A good dog is a medicine for melancholy & a better stress reliever than Valium.

It is hard to express pain or grief when life wounds us or

takes those we love. Grief easily leads to despair. In the fertile ground of despair, self-pity can sprout & thrive. I cannot begin to indulge in self-pity because I will be digging a hole so deep that I'll never again be able to crawl out of it. I have to be somewhat cold in order to survive. So I live w/a chinkless shell around my heart. I'm able to express my love for the living, while in torment for Monty's death. I miss my parents, grandparents, relatives & friends who have been taken by death. But Monty has left a horrible, non-stop pain, which threatens my descending from grief to despair to self-pity to the pit of inescapable rage & loneliness & self hatred. I remain on the edge with fear of falling.

We live in a society in freefall —

I tried to raise Monty to play, to have fun, to indulge his sense of wonder, to live as much as possible without fear, to trust in God, & to believe that everyone is here for a purpose... to be grateful for his talents, skills — & limitations because they are part of a design beyond comprehension. He learned how important self-discipline & respect for others are. Those things seemed to come naturally to him because I believe he knew that his life had a spiritual dimension & he was a carefully designed element in the mysterious mosaic of life.

So many people still speak about the way Monty would light up a room — The glorious light of him that blazed but never burned —

Dec. 15, 2003

Monty was so full of life that it seemed as if he would never run out of it.

We are the most alive & the closest to the meaning of our exist-ence when we are most vulnerable, when experience has humbled us & has cured the arrogance which, like a form of deafness, prevents us from hearing the lessons this world teaches.

Dec. 19, 2003

Our convictions & our friends are all that we have to get us through times of trouble. Friends are the only things from this damaged world that we can hope to see in the next. Loved ones & friends are the very light that brightens the hereafter.

Thinking back to this day, 1998— Monty & I were so ~~fif~~ filled with HOPE... A better 1999... In the un-certain space between birth & death,

we need hope as much as we need food, water, love, & friendship. Now I realize that the trick is to remember that hope is a perilous thing — that it is not a concrete bridge across the void between this moment & a brighter future. Hope is really no stronger than tremulous beads of dew strung on a filament of spider web. It alone cannot long support the horrible weight of an anguished mind & a tortured heart.

This year hope has gone away as I drown in the worst of all calamities, the loss of my son. I can no longer run across a bridge of hope, a high arched span, which has dissolved like gossamer & directed my attention to the chasm beneath me.

I am on a perilous emotional edge. The threat of my own death troubles me far less. I am crushed flat by the loss of Monty. Grief is sharper than

the tools of any torturer.

...we try...to discover our own personal truth. This truth always causes much

Dec. 20

Bevy is SO SPECIAL! I believe that dogs were placed on earth to remind us that love, loyalty, devotion, patience, courage, & good humor are the qualities, with honesty, are the essence of admirable character & the definition of a life well lived. Spuds, Boki, Gef, Mama, Demon, Most Precious Presley, Drama, Premire, Blackie, Snoopy, Iraski — all have been what I needed during the happy years. But none has been as close as Bevy.

Yet it is in our idleness, in our dreams, that the submerged truth
sometimes comes to the top.

Virginia Woolf, A Room of One's Own

Ultimately, the only way to get through something is to get through it —

ot over, under, or around it, but all the way through it.

Alla Bozarth-Campbell, Life is Goodbye/Life is Hello

...loss constitutes an odd kind of fullness; despair empties out into an unquenchable appetite for life.

Gretel Ehrlich, The Solace of Open Spaces

**A strong woman is a woman determined
to do something others are determined
not be done**

Marge Piercy, Circles on the Water, For Strong Women

The paradox: there can be no pilgrimage without a destination, but the

destination is also not the real point of the endeavor.

Patricia Hampl, Spillville

...sometimes the best outcome is being able to see that there are things in life
which are neither understandable or acceptable — and in understanding, and
accepting that, real peace can come.

Alla Bozarth-Campbell, Life is Goodbye/Life is Hel

We are often like rivers: careless and forceful, timid and dangerous,

lucid and muddied, eddying, gleaming, still.

Gretel Ehrlich, The Solace of Open Spaces

I hold this to be the highest task of a bond between two people: that each

should stand guard over the solitude of the other.

Rainer Maria Rilke, Rilke on Love and Other Difficulties,

Oh, close your eyes tight and push hard
and evolve, altogether now. We can
do it if we try. Concentrate
and hold hands and push.
You can take your world back
if you want to.

Marge Piercy, Circles on the Water,
For Strong Women, from the poem
Let us gather at the river

The real passion, not for someone. But the brief season when the exultant

act of existence courses madly through you.

Patricia Hampl, Spillville

...the lessons I finally learned were, don't try to get blood out of a rock, and if

people reject your power and passion, it is because they reject their own.

Charlotte Davis Kasl, Women, Sex, and Addiction

All through autumn we hear a double voice: one says everything is ripe; the

other says everything is dying. ~~The paradox is exquisite.~~ ⚹

Gretel Ehrlich, The Solace of Open Spaces

Take action, even if you fear failure. If you make a wrong choice, the

consequence is simply that you have to keep making choices.

Sharon Wegscheider-Cruse, ChoiceMaking

BUT WHAT HAPPENS WHEN THERE ARE No MORE CHOICES?

Simply notice;
 Choose and play with options;
 and
 Be in process.

Richard D. Carson, Taming Your Gremlin

There are really only two ways to approach life — as victim or as gallant fighter.

Merle Shain, When Lovers are Friends

Be gentle with yourself. Prepare for change by inviting it.

Philip Oliver-Diaz and Patricia A. Gorman, 12 Steps to Self-Parenting

Learning to love differently is hard,
 love with the hands wide open, love
 with the doors banging on their hinges,
 the cupboard unlocked...

Marge Piercy, The Moon is Always Female, To have without holding

...accept yourself...dance lightly with your goblins...open yourself t

the lessons the Universe places in your lap every day of your life.

Charlotte Davis Kasl, Women, Sex, and Addiction

If you are filled with gratitude for what you have, you will feel abundant. And

You cannot feel abundance and scarcity at the same time.

Sharon Wegscheider-Cruse, ChoiceMaking

By being patient we are rewarded. We recognize that most spiritual experience

are slow, gradual, more like the unfolding of a flower than a thunderbolt.

Philip Oliver-Diaz and Patricia A. Gorman, 12 Steps to Self-Parenting

The gods sometimes create trouble; it is not always just man. In nature herself

here are deficiencies, incompleteness and disharmonies.

Marie-Louise von Franz, The Feminine in Fairytales

Each of us must make his or her own separate way through an indifferen

unfamiliar landscape in which good is not necessarily rewarded, nor evil punished.

Sheldon Kopp, An End to Innocence

That pine, my eye is led up and down the straightness of its trunk, my muscles

eel its roots spreading wide to hold it so upright against the hill.

Joanna Field, A Life of One's Own

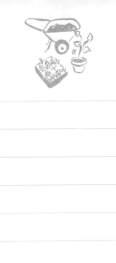

The pain of loss, the loneliness, the anger, and the frustration would have to b

converted to fuel, energy for new growth and new life. Another me.

How?

Kaylan Pickford, *Always a Woman*

Go toward whatever feels light, and avoid whatever feels dense. Light energ

...fire energy, the source of transformation.

Charlotte Davis Kasl, Women, Sex, and Addiction

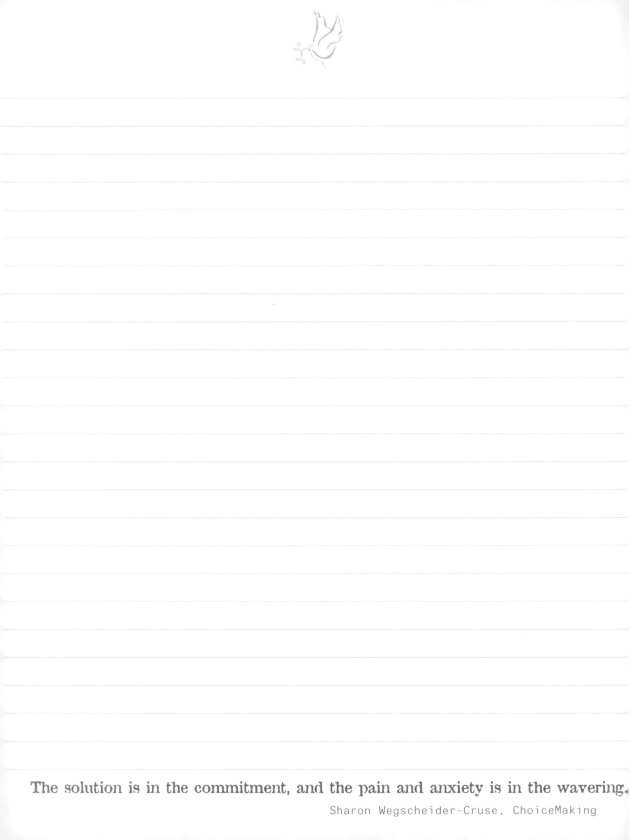

The solution is in the commitment, and the pain and anxiety is in the wavering.

Sharon Wegscheider-Cruse, ChoiceMaking

There is no doing it right; there is just being with what is as wholeheartedly as the moment allows.

Stephen Levine, Healing Into Life and Death

Trouble may be situational, but worry is always a state of mind. Accepting

painful experiences openly and honestly eliminates needless suffering.

Sheldon Kopp, An End to Innocence

Weaving a cocoon out of the substance of one's own life is the necessar

prerequisite for the emergence of psyche: in withdrawing we prepare a way out.

Nor Hall, The Moon and the Virgin

We tend not to choose the unknown...and yet it is the unknown with all it

disappointments and surprises that is the most enriching.

Anne Morrow Lindbergh, Gift From the Sea

Life is a journey to be experienced, not a problem to be solved.

Philip Oliver-Diaz and Patricia A. Gorman, 12 Steps to Self-Parenting

BUT A JOURNEY FILLED WITH PROBLEMS!

...enlightenment does not provide perfection. Instead, it simply offers the

pedestrian possibility of living with the acceptance of imperfection.

Sheldon B. Kopp, If You Meet the Buddha on the Road, Kill Him!

gift

STEWART, TABORI & CHANG

Copyright © 1996 Stewart, Tabori & Chang
Illustration Copyright © 1996 Kari Alberg

Published in 1996 by
Stewart, Tabori & Chang
A division of U.S. Media Holdings, Inc.
115 West 18th Street
New York, NY 10011

Distributed in Canada by
General Publishing Company Ltd.
30 Lesmill Road
Don Mills, Ontario, Canada M3B 2T6

Creative Director: Mia Galison • Designer: Brenda Brown Fortunato
Quotes gathered by Jan Borene

ISBN: 1-55670-520-4

PRINTED IN HONG HONG

1 0 9 8 7 6 5